A MURDER OF CROWS:
AND OTHER HORRIBLE THINGS TO SEE

TO LIFE
(FOR OBVIOUS REASONS.)

© 2017 CHRISTIE SHINN AND HORATORA STUDIOS. ALL RIGHTS RESERVED.

FOREWORD

The world is fucked and everything is the worst.

Christie gets that. It's how we bonded in the first place and why we became fast friends.

The difference between Christie's melancholy sadness and most of the morose motherfuckers on the planet is that even though she sees all the shit in the world, it doesn't stop her from raging against it.

She took all her shitty relationships and brought them to life in the beautiful *Personal Monsters*, which was the first of Christie's books I fell in love with, and has brought her biting vision of the world into every one of her books since, including this one. Anger, passion, and love flow out on to the page. She bleeds her soul onto every canvas, and her passion for creation shines through with every brush stroke.

When Christie first asked me to write the foreword for this book, I didn't hesitate for even a second before telling her fuck yeah. I didn't even have to see any of the pages. I just knew they would be awesome because everything she does is awesome.

She did not disappoint.

A Murder of Crows is full of hauntingly beautiful, raw moments that I've always loved about her work. Fuck you, Christie, for making something so beautiful that it made me feel all the things.

Russell Nohelty
Wannabe Press

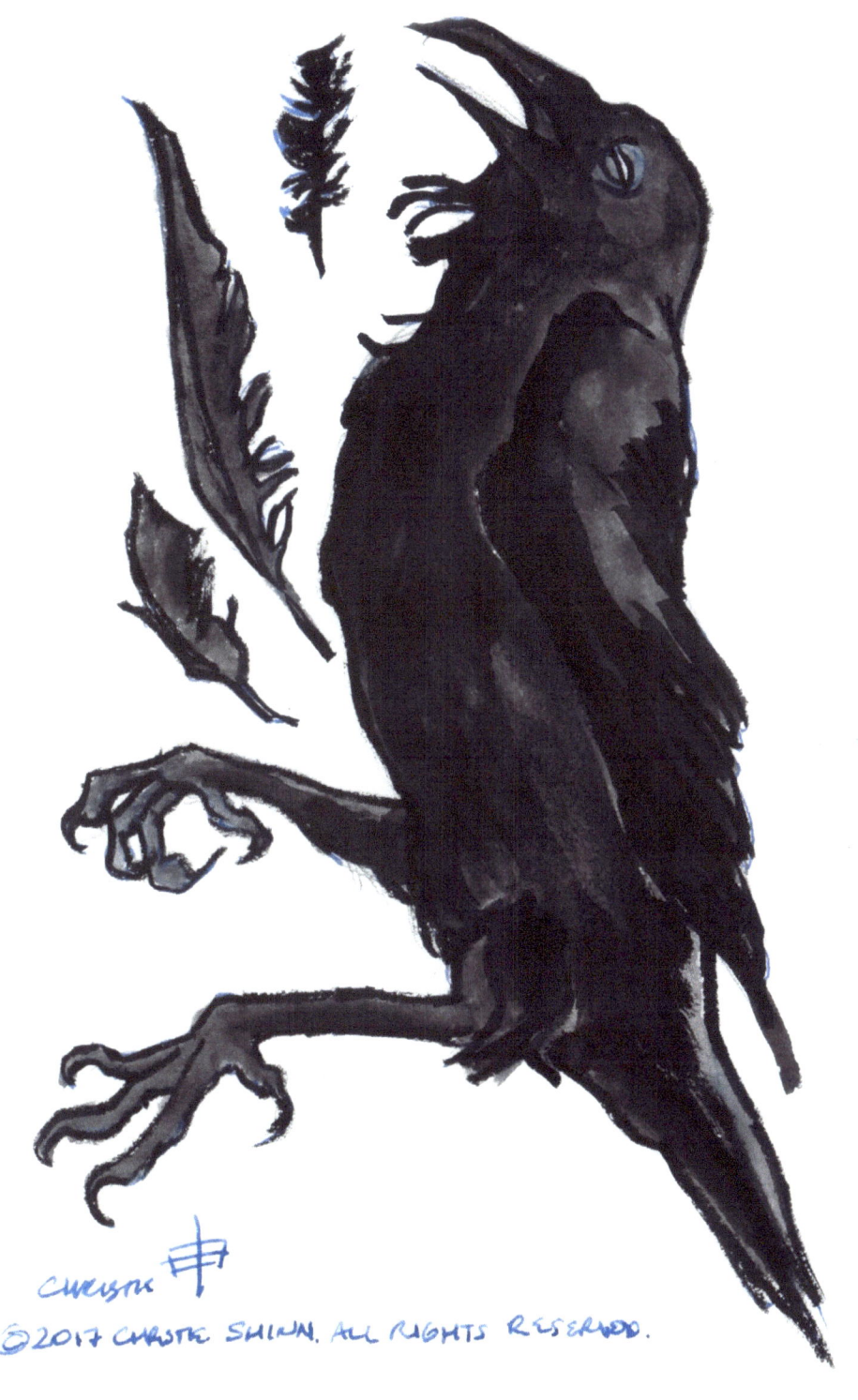

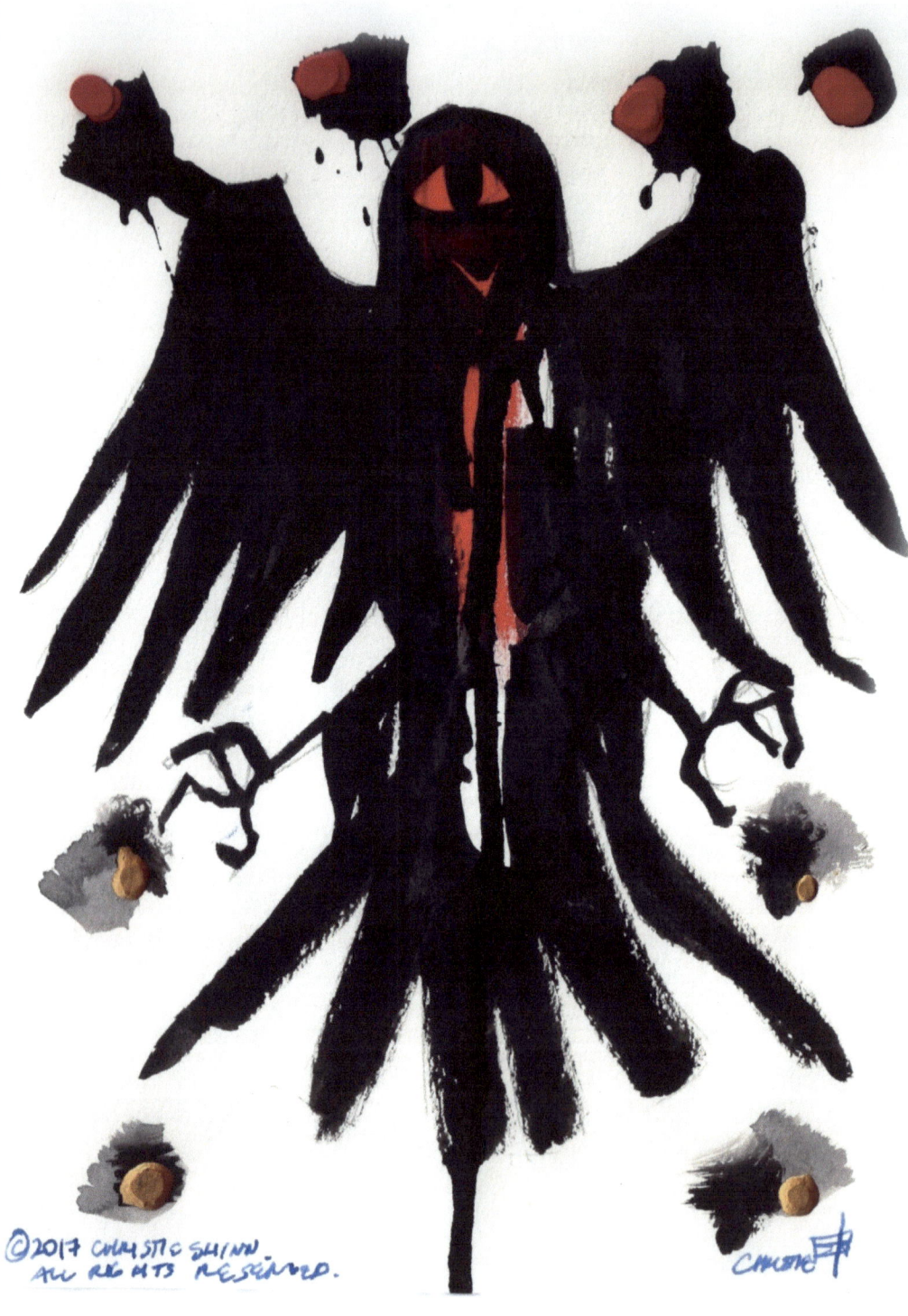

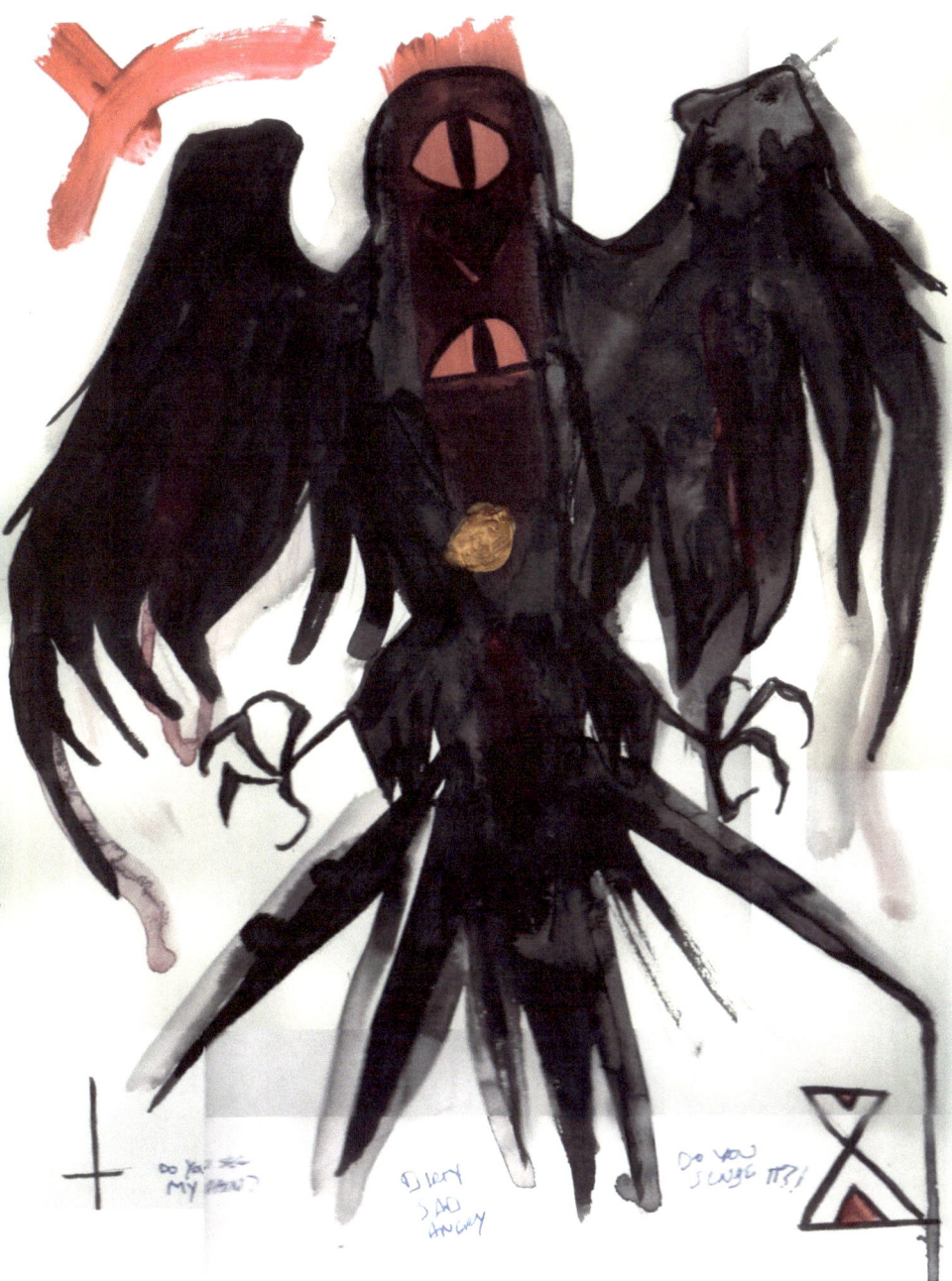

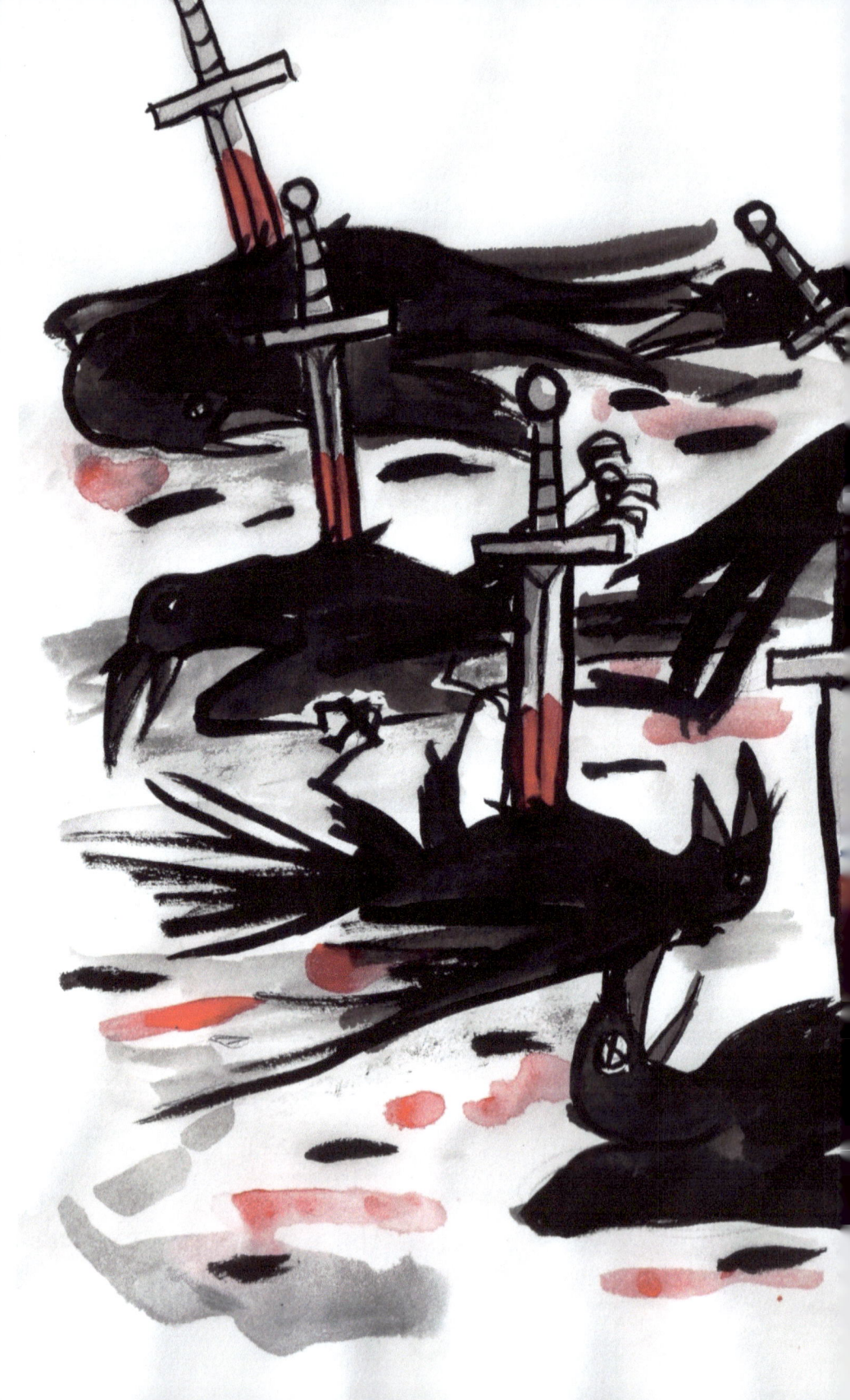

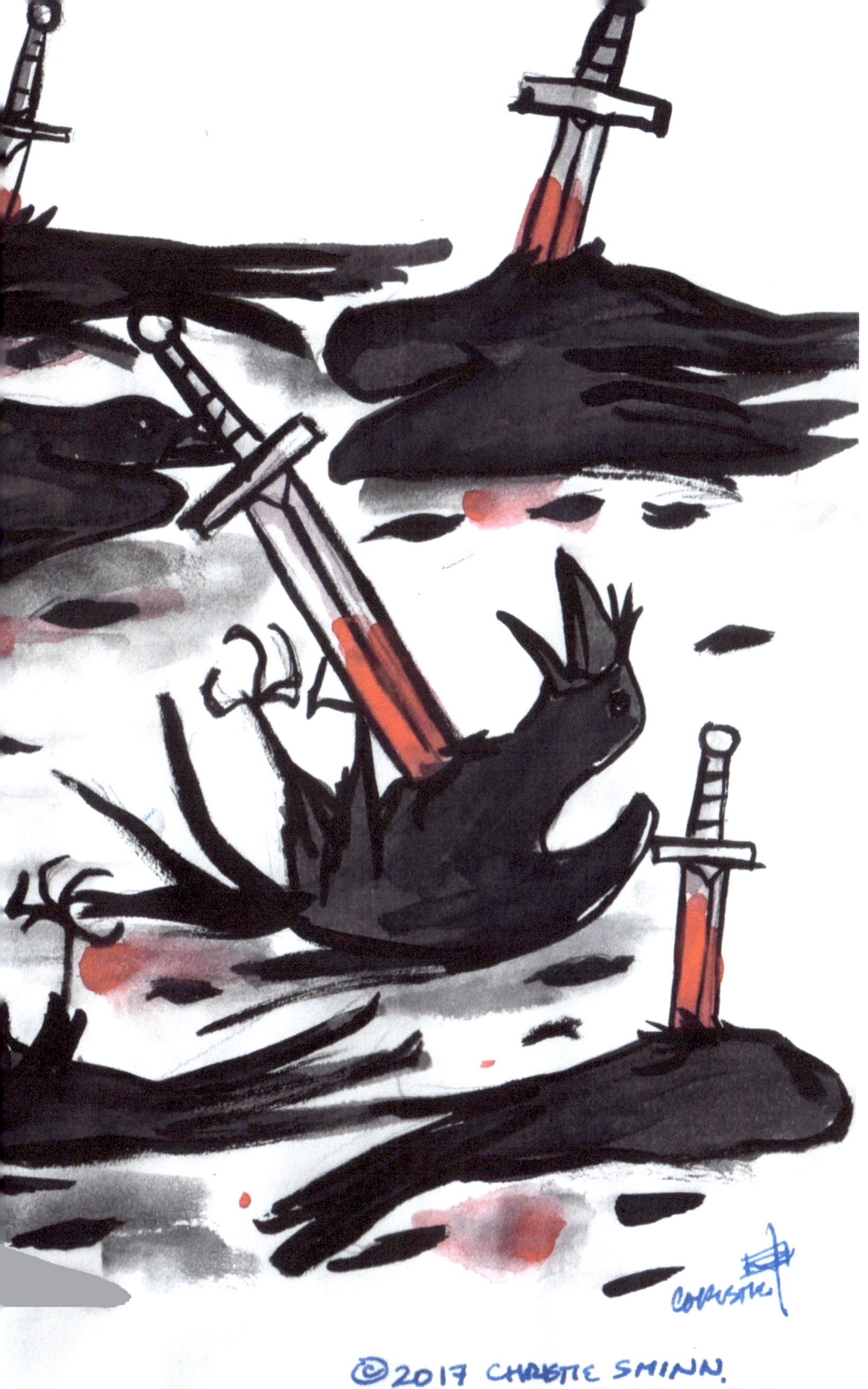

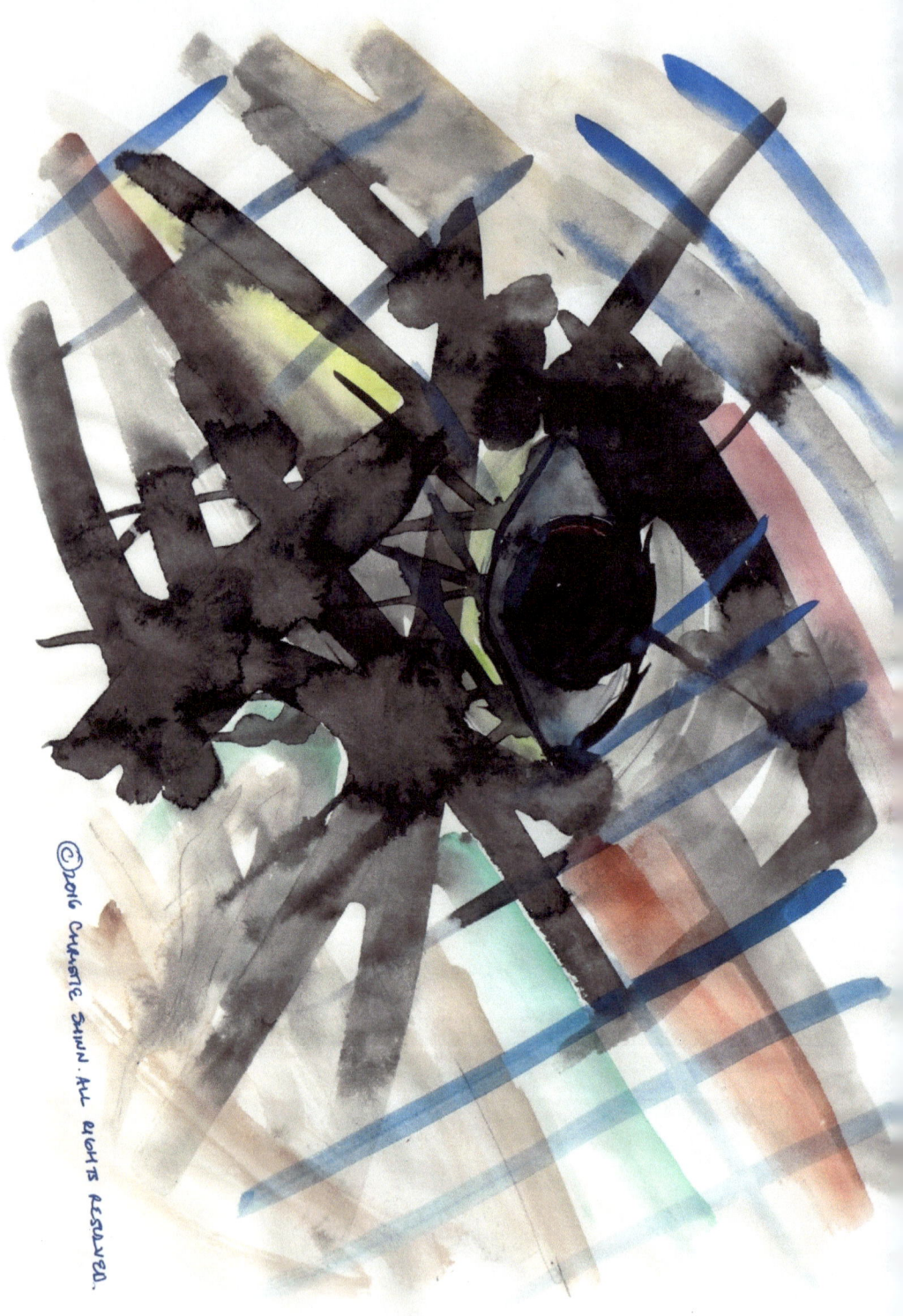

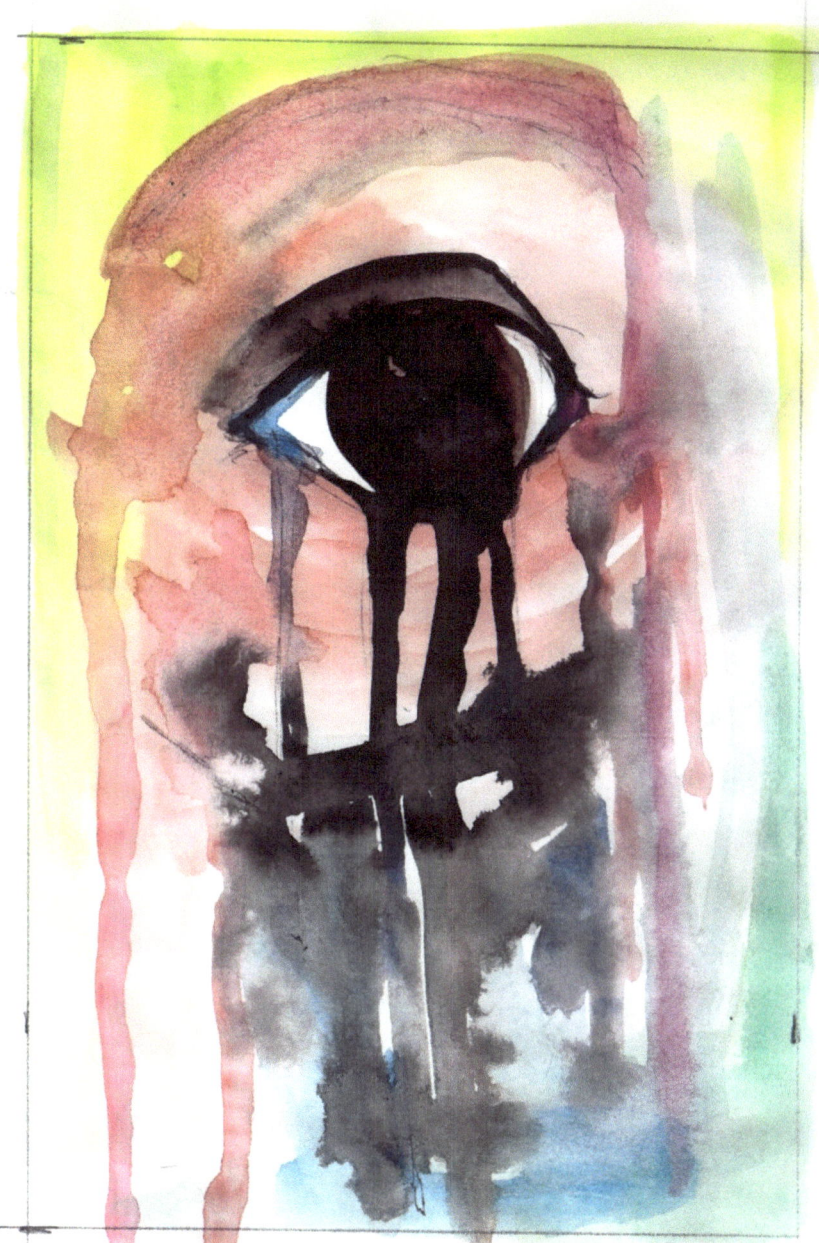

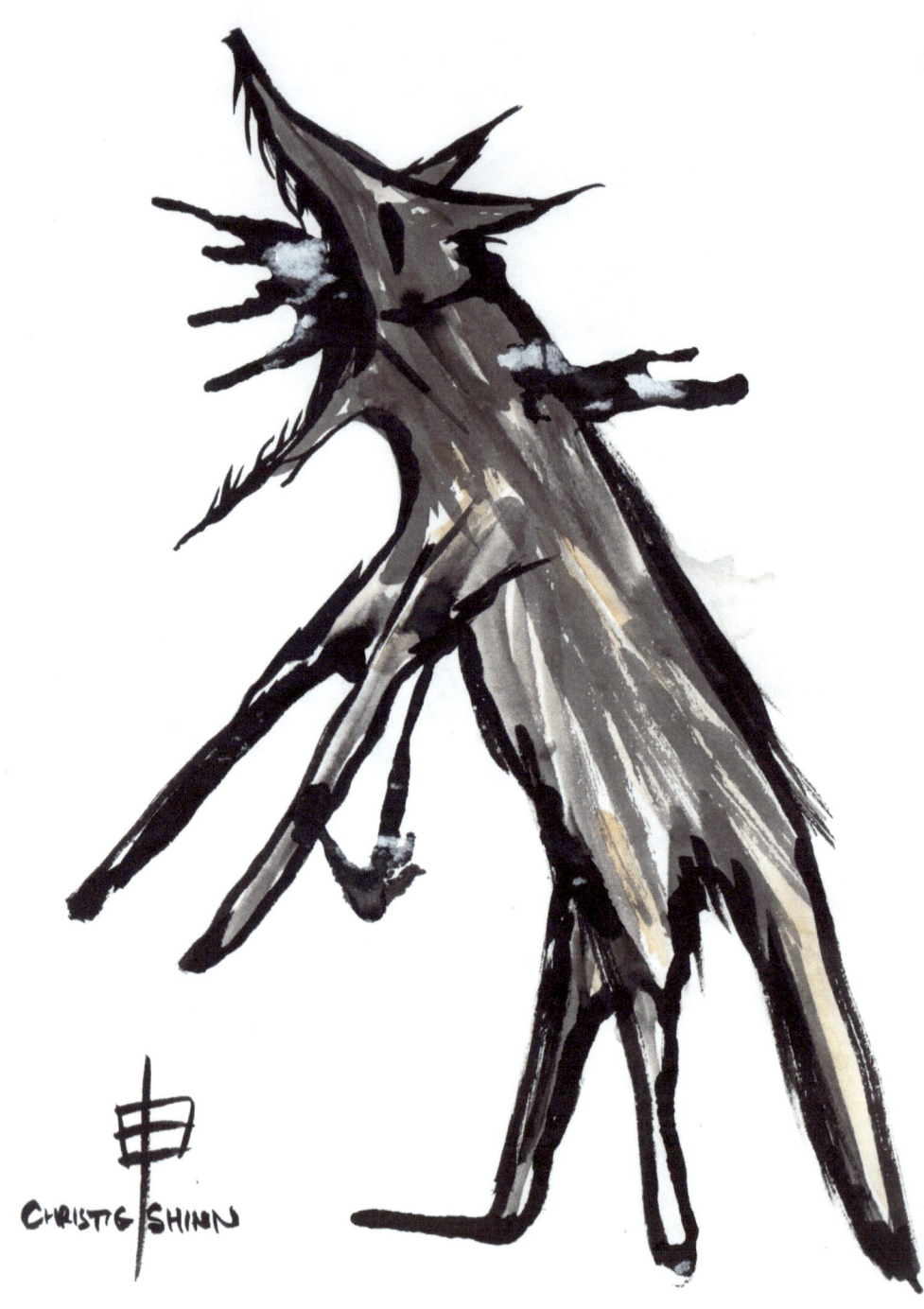

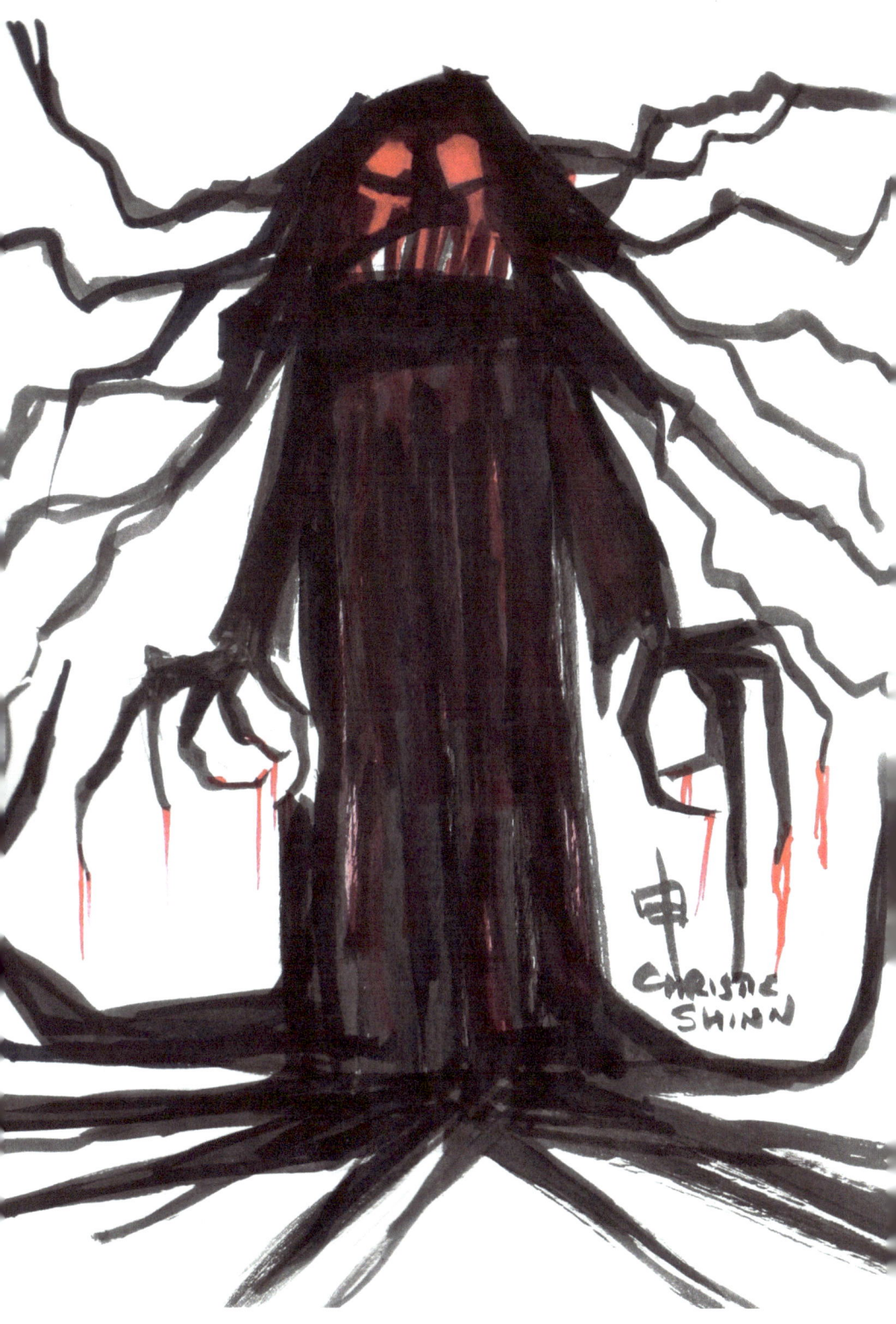

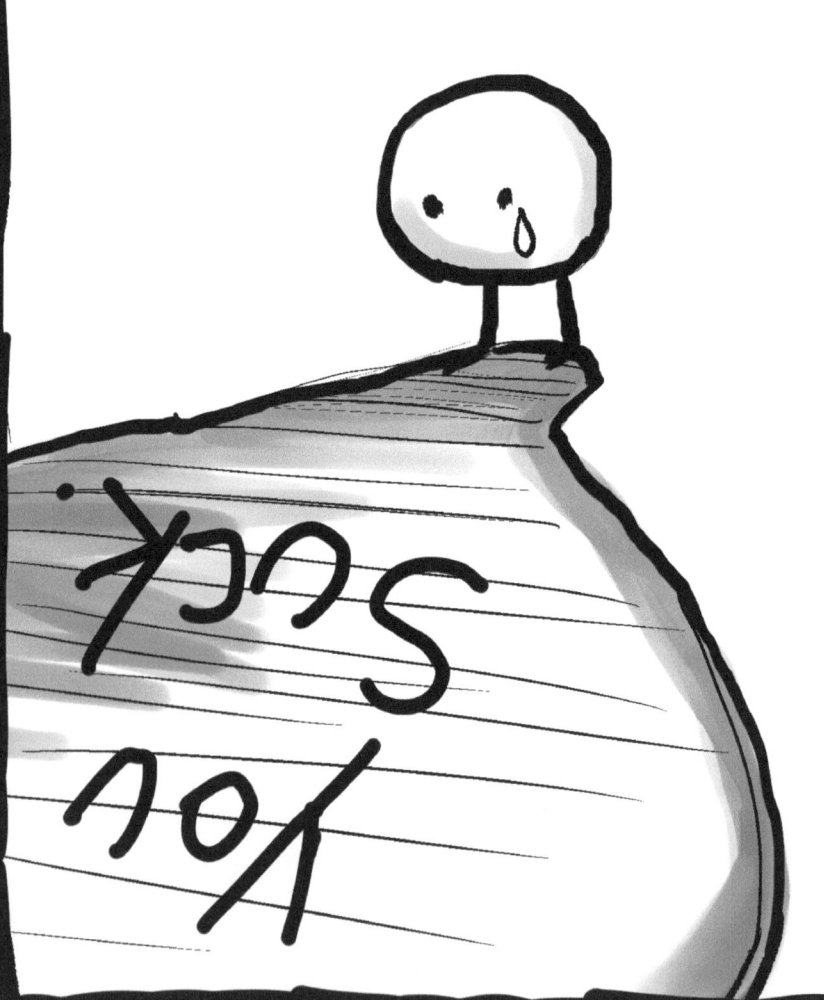

"Dark"

© 2016 Christie Shinn. All rights reserved.

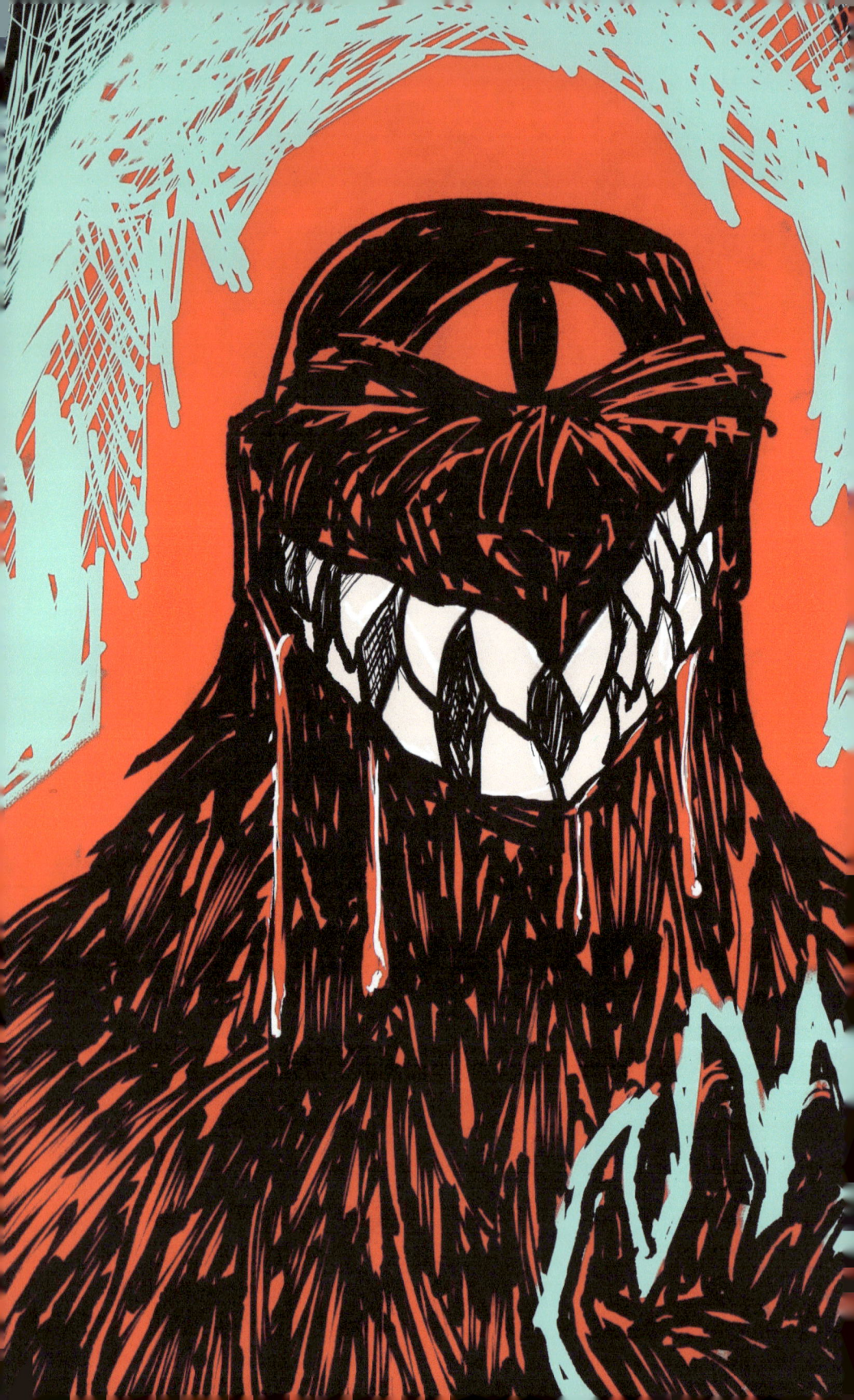

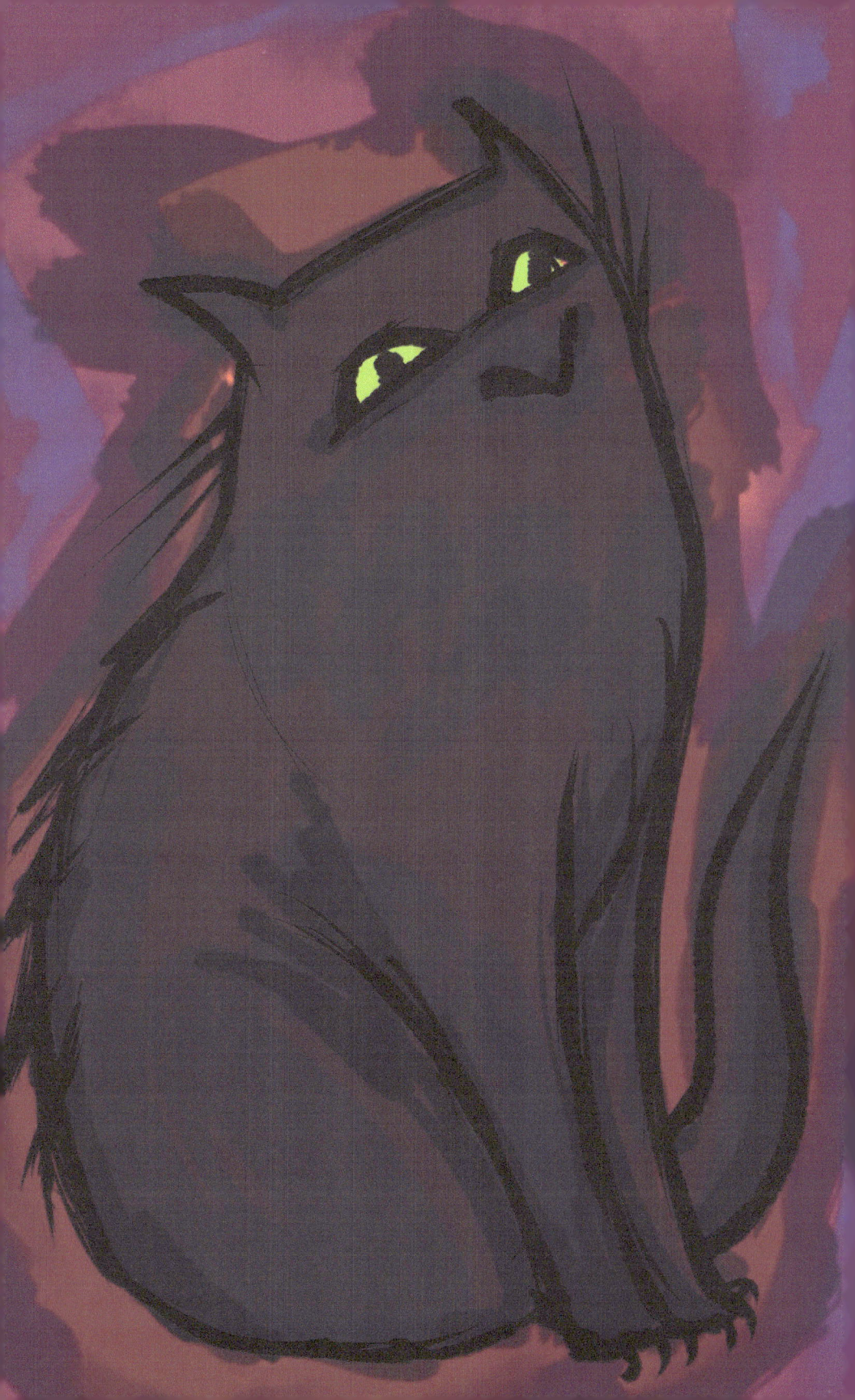

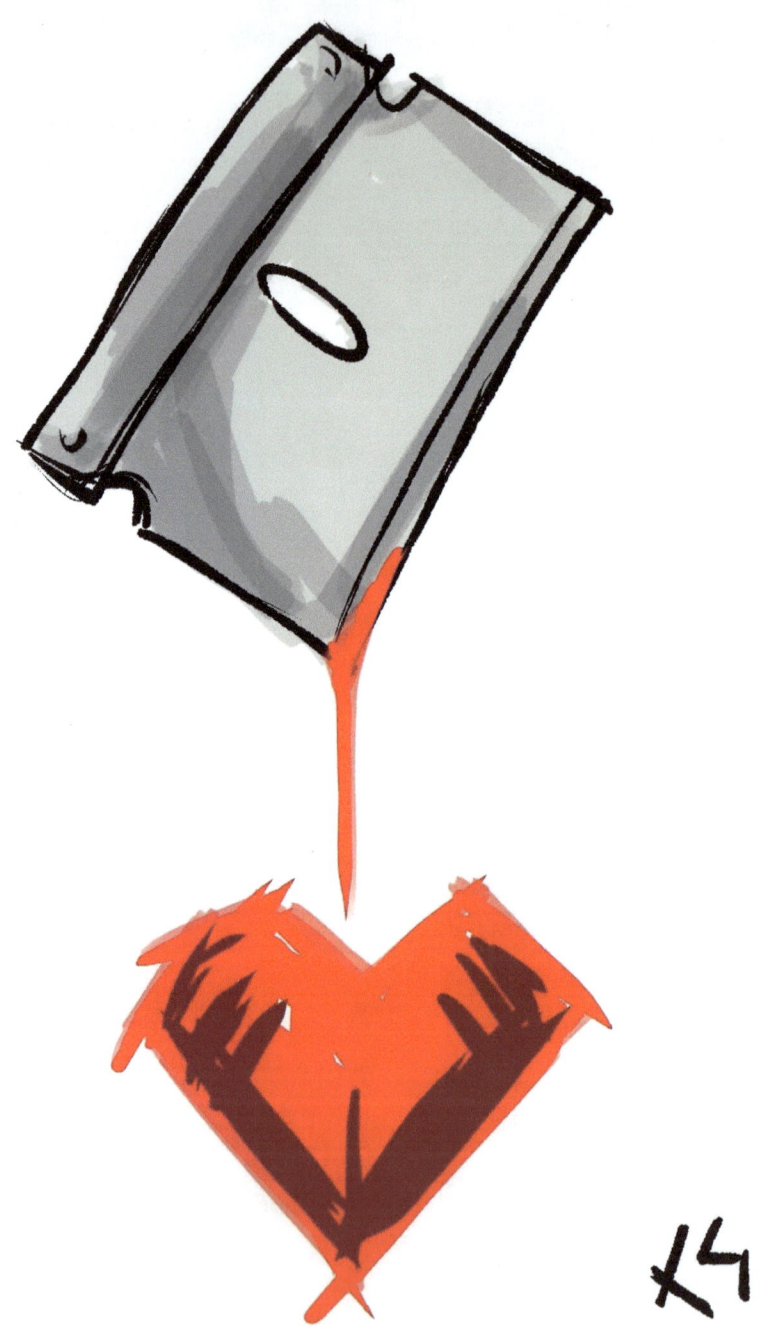

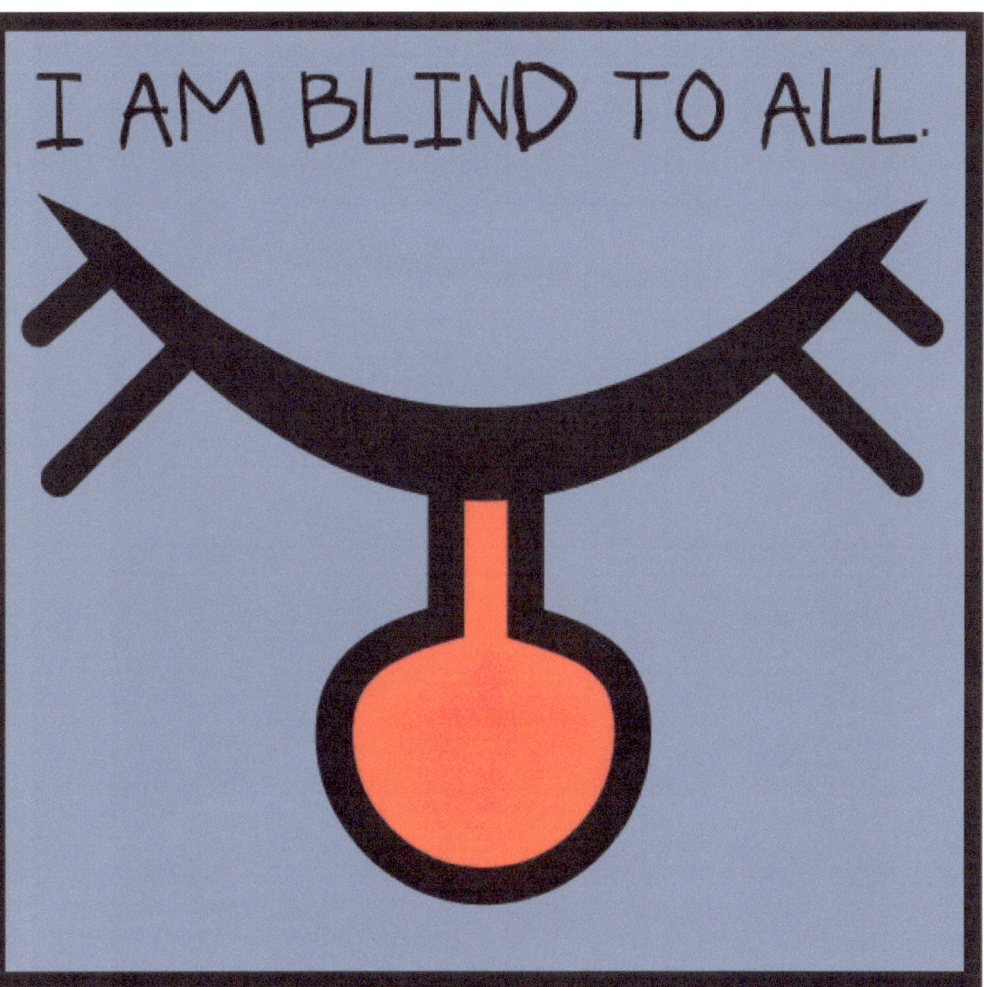

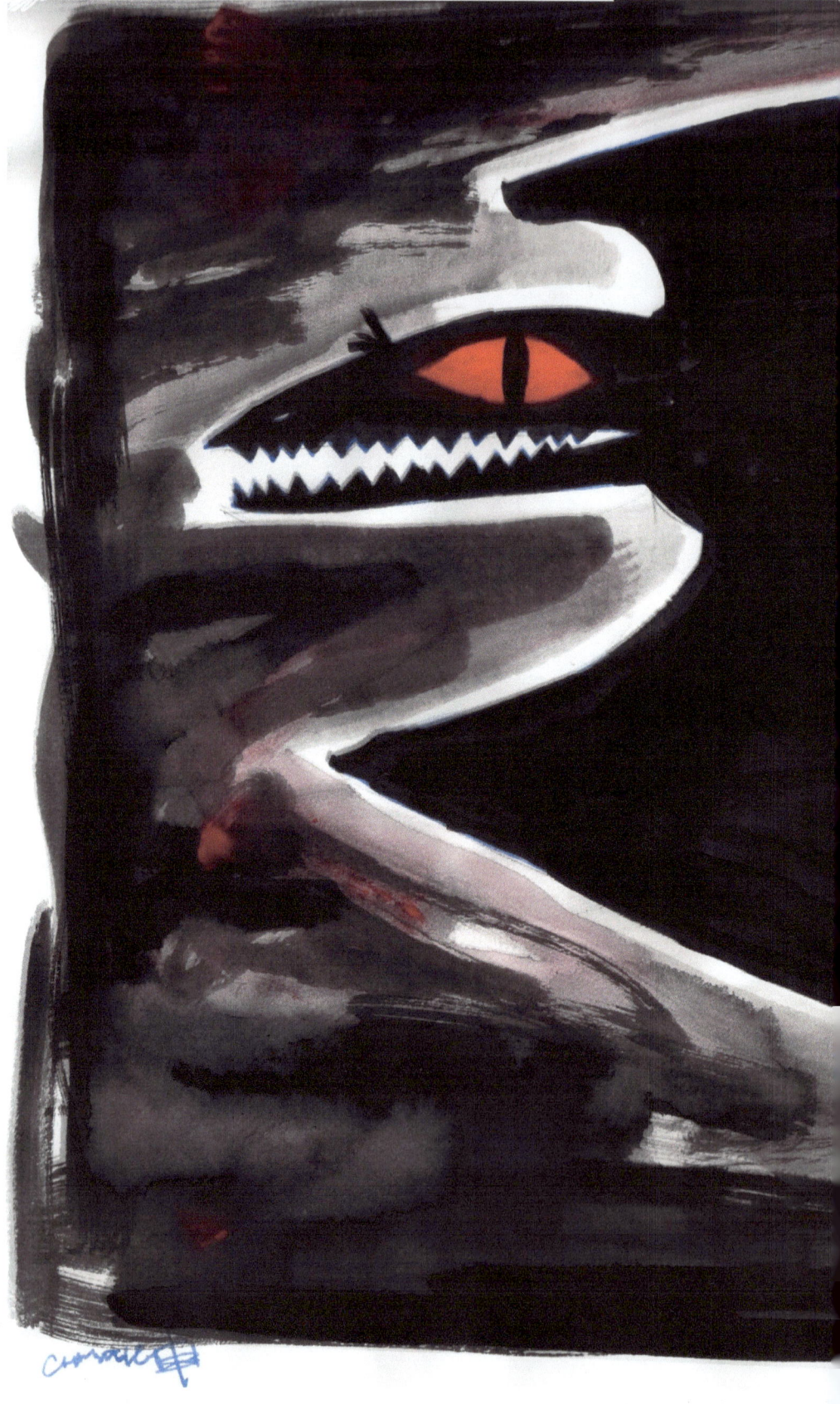

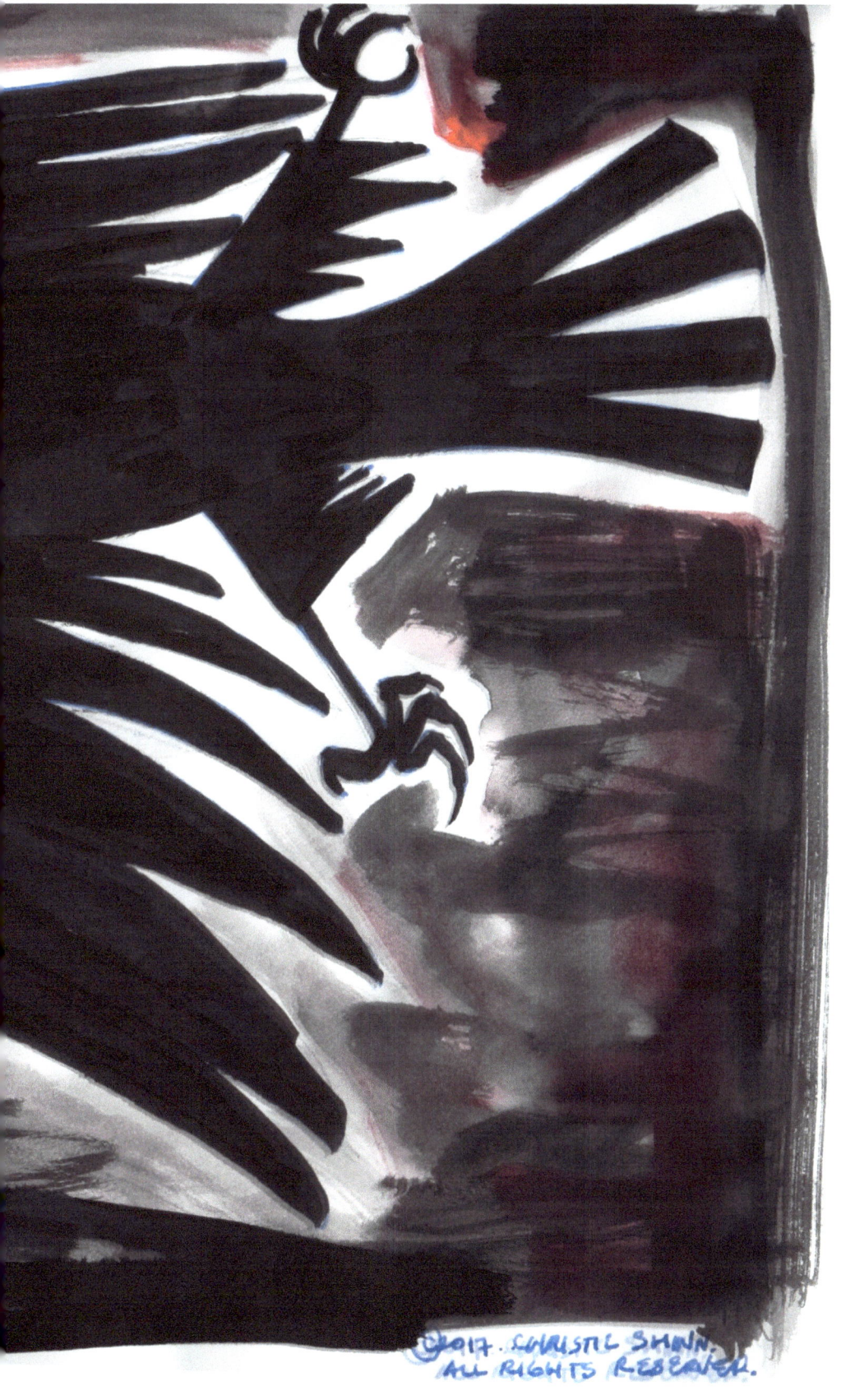

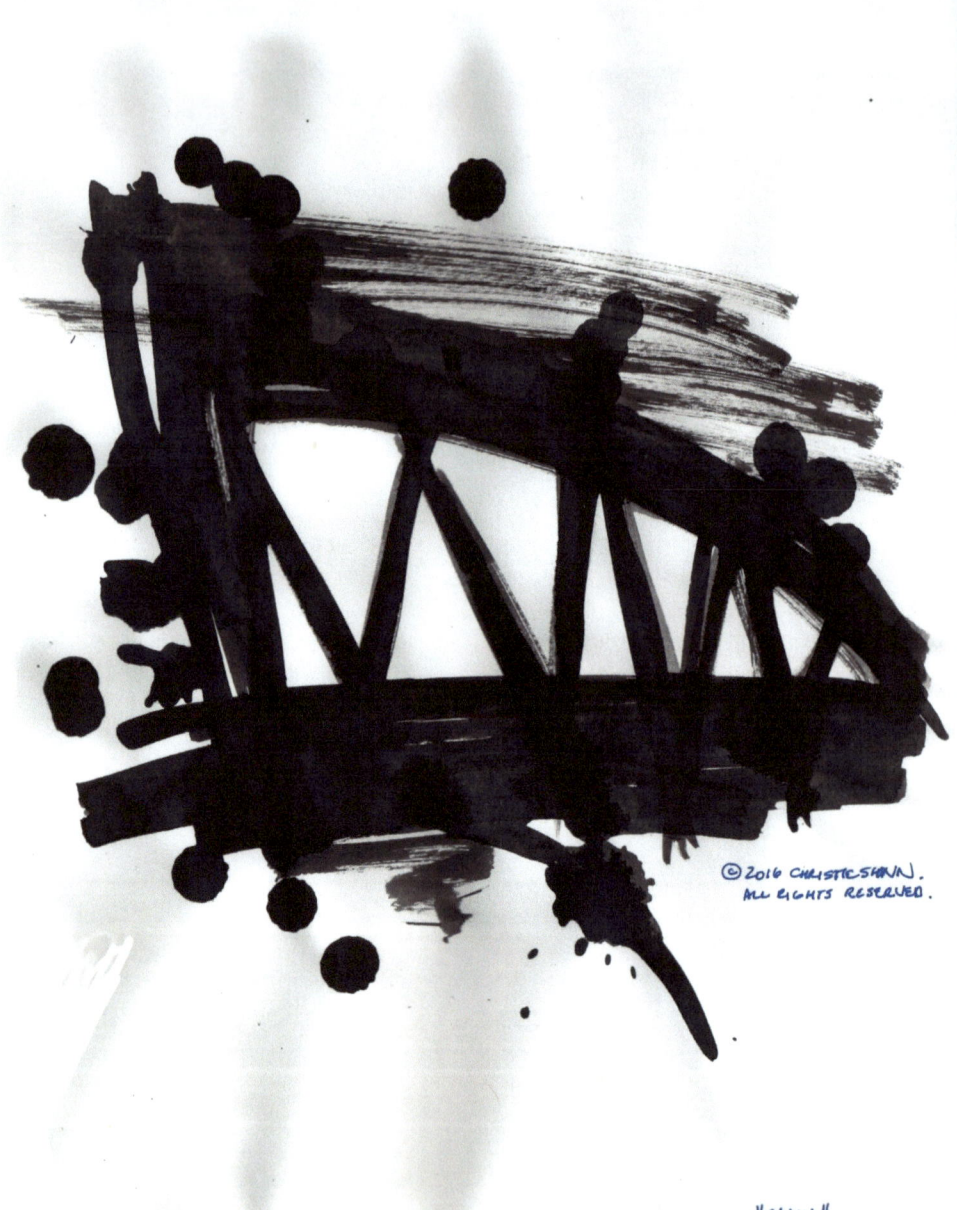

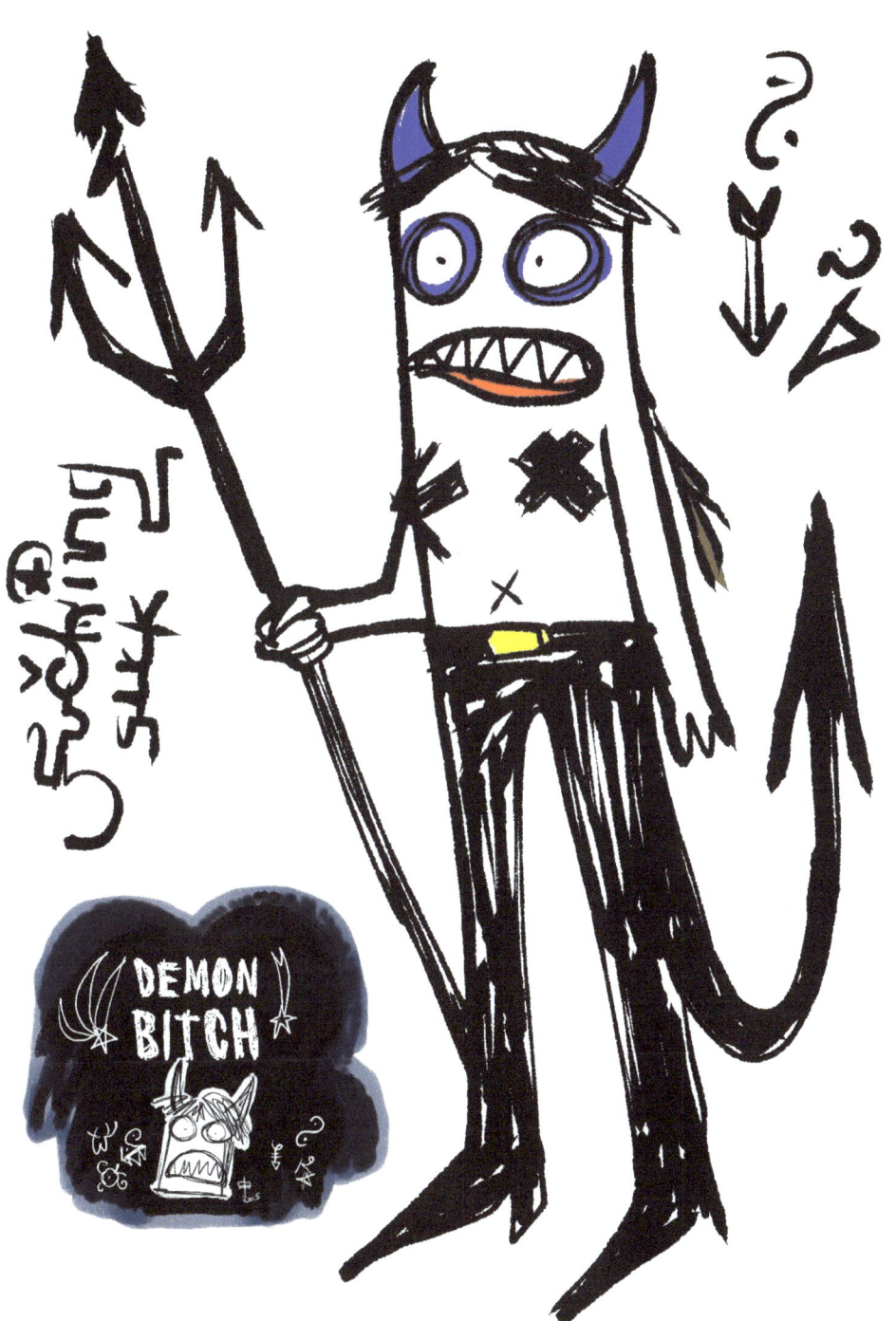

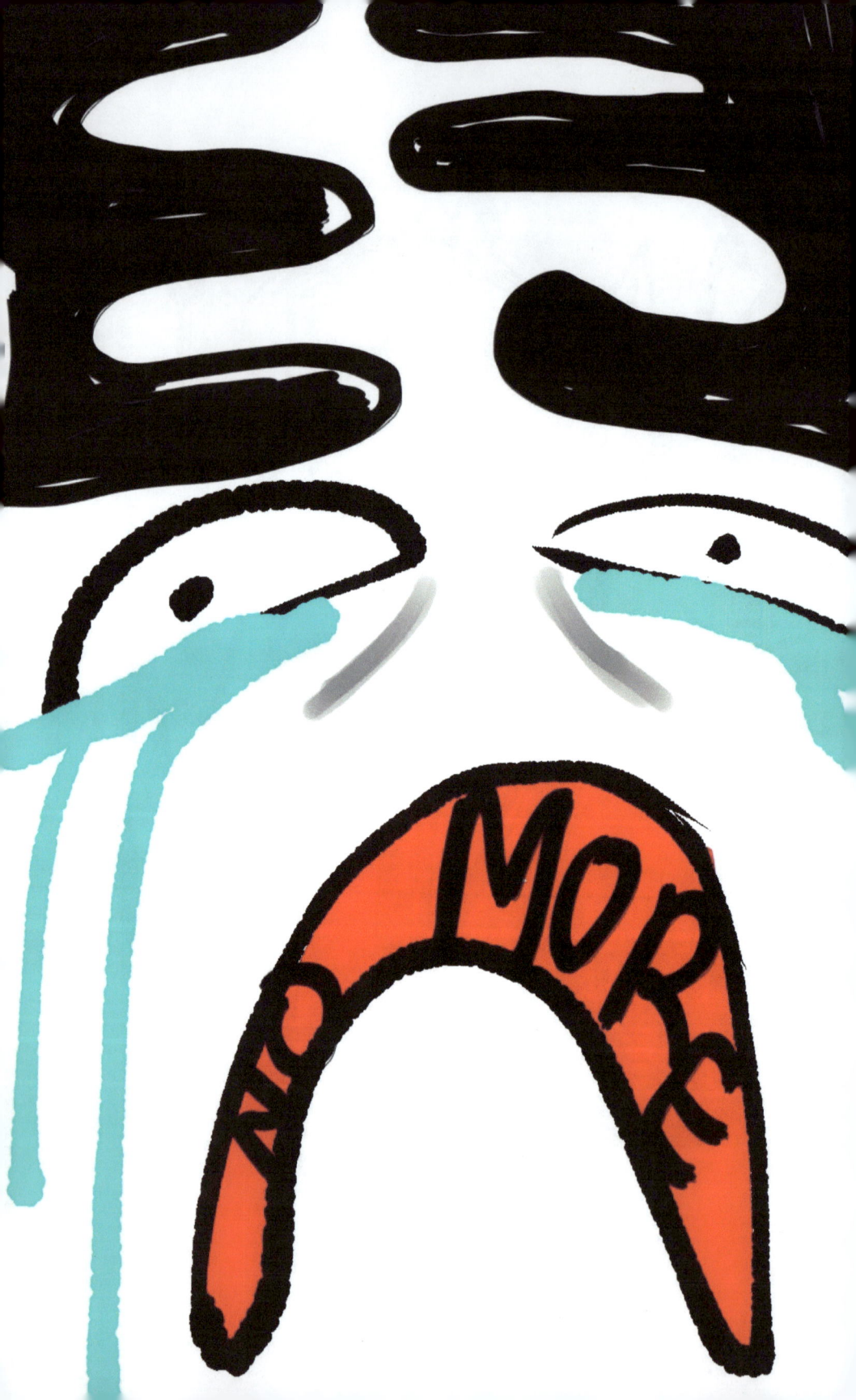

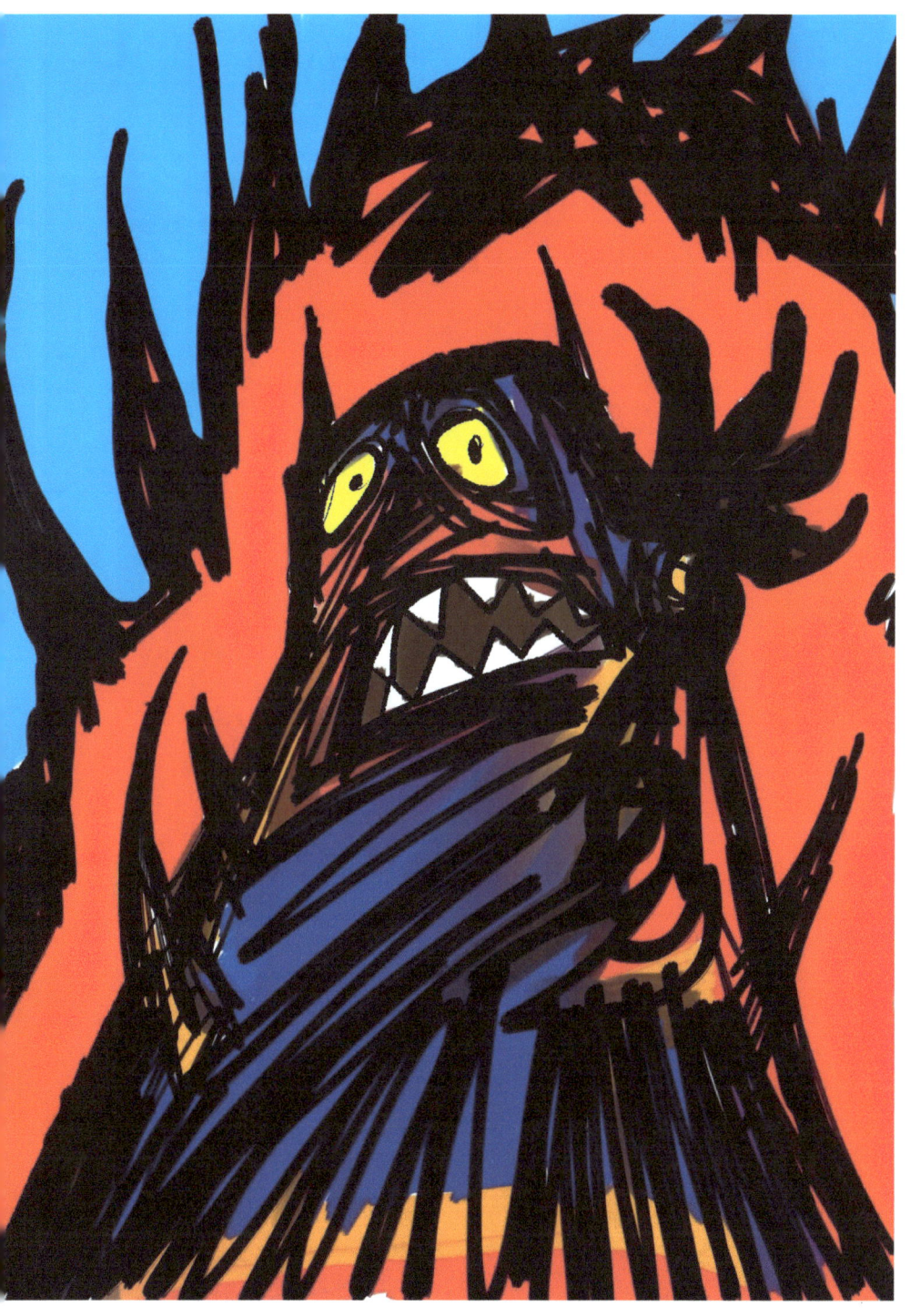

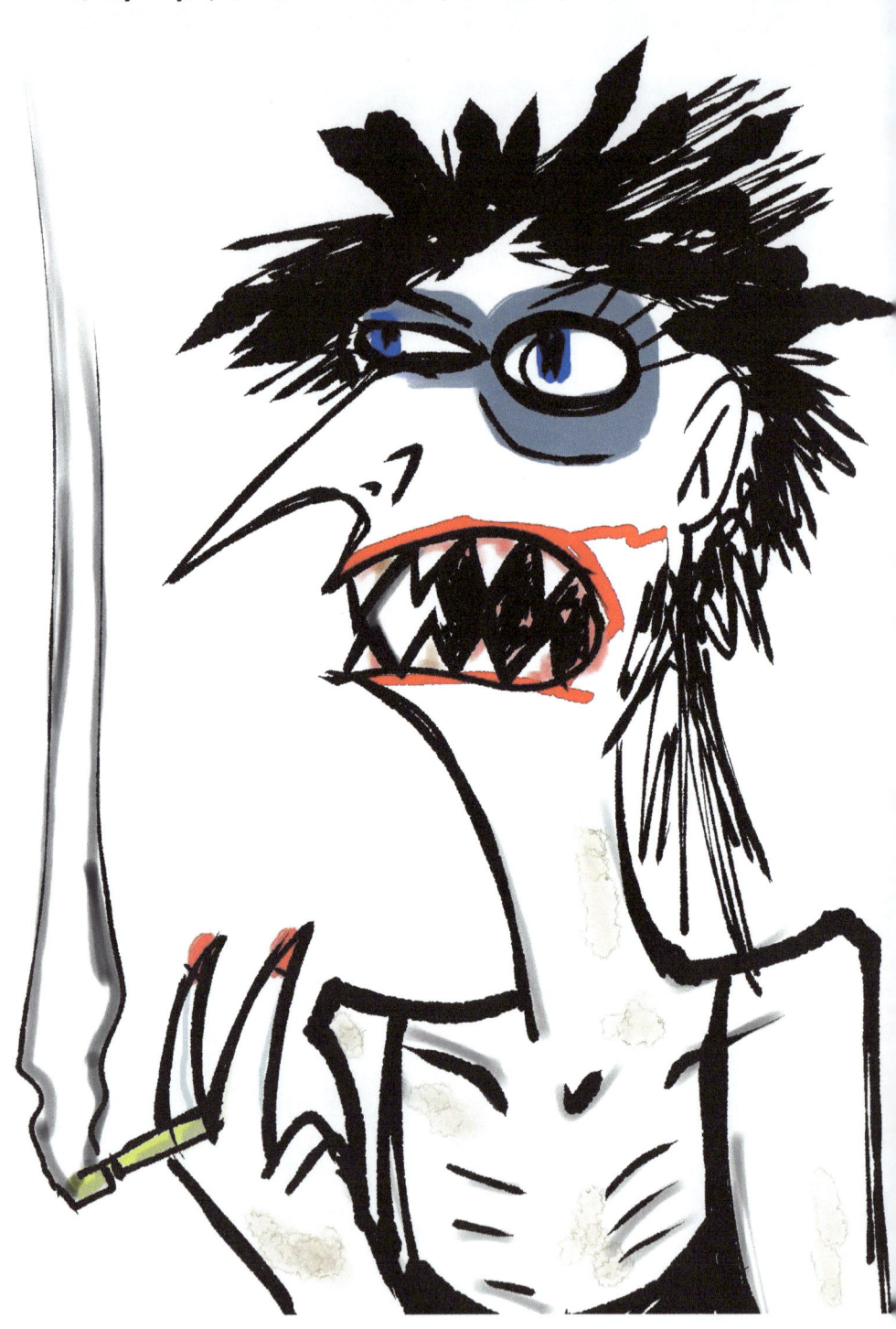

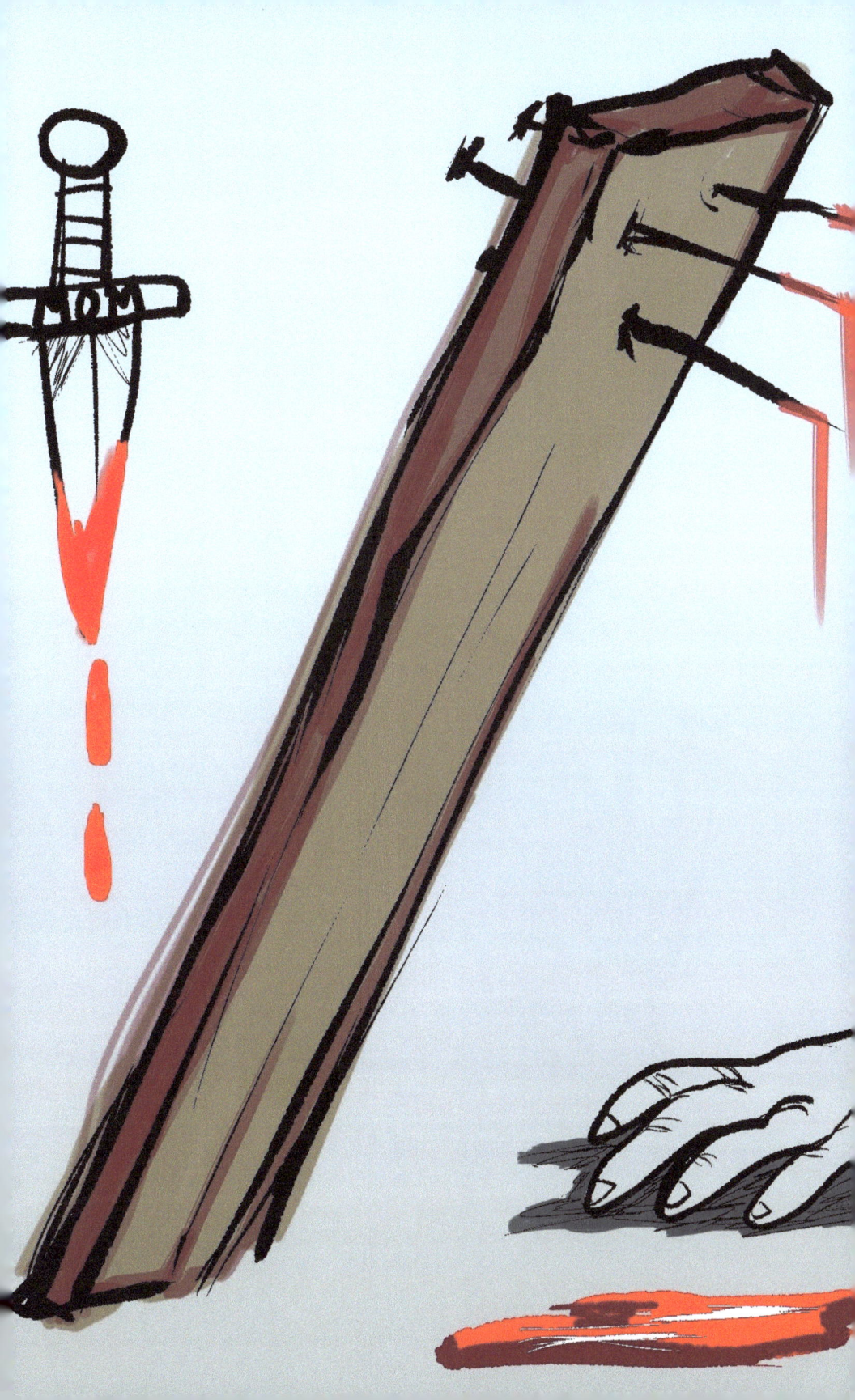

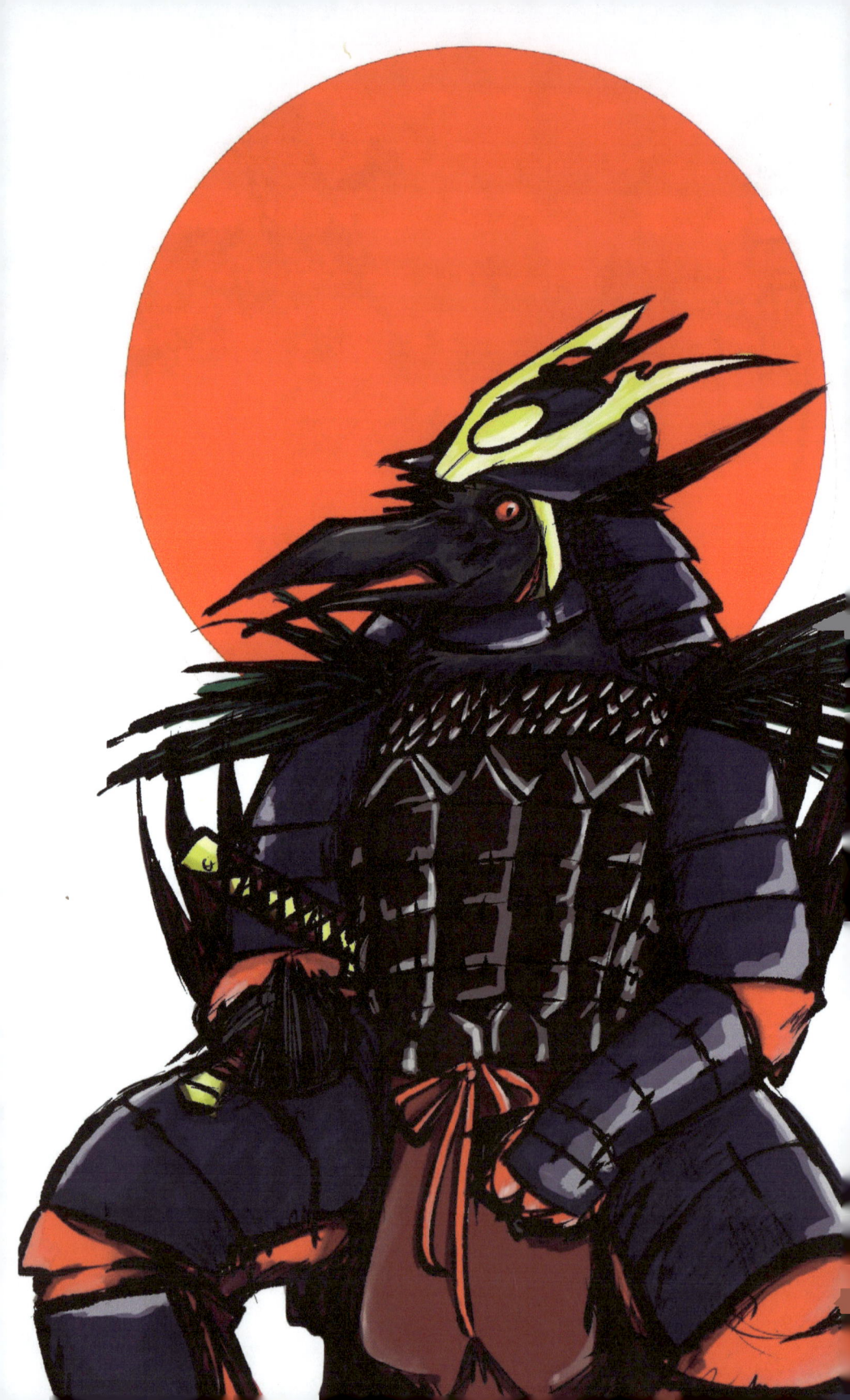

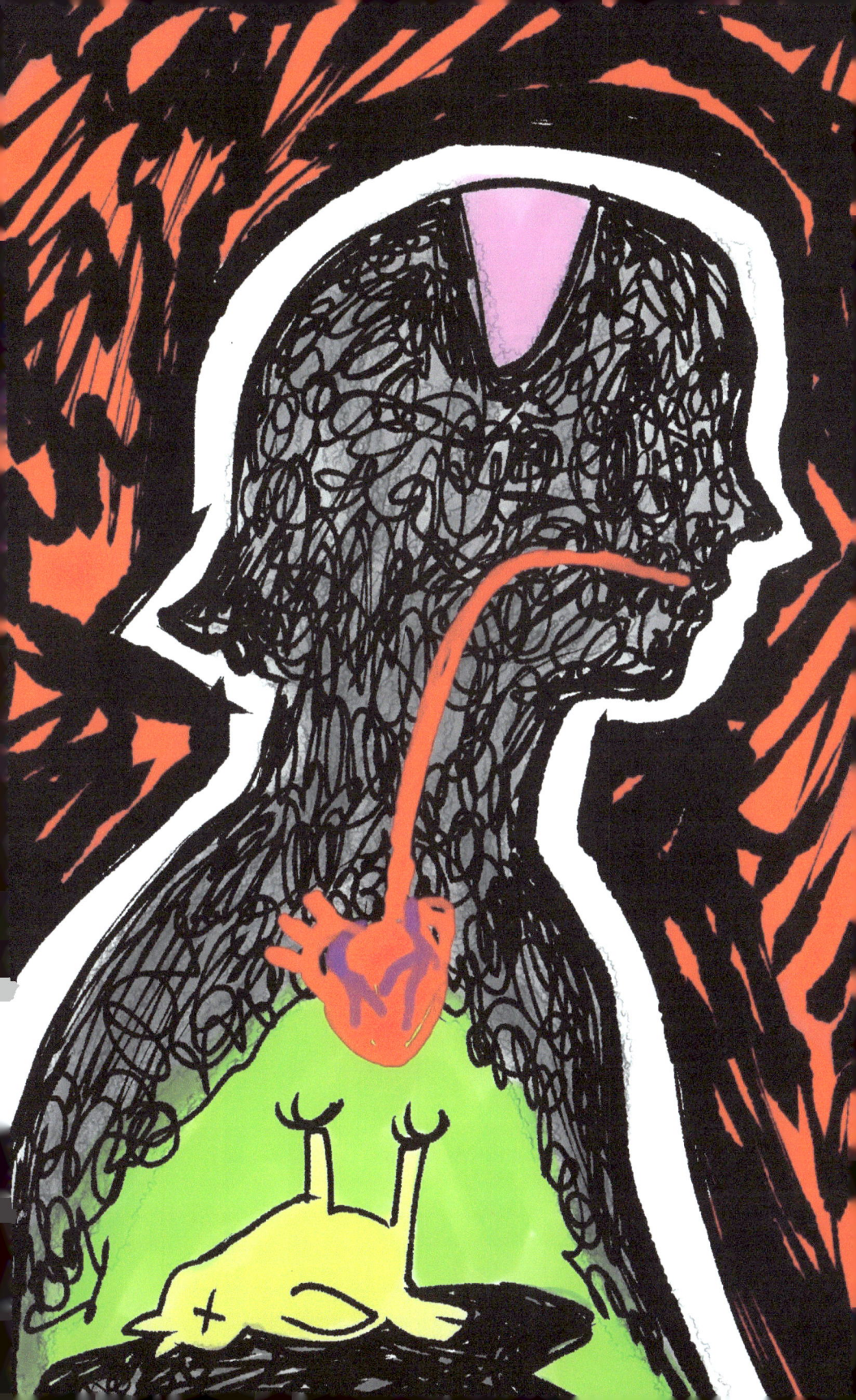

THE END

(MAKE THE MONSTER YOUR BITCH.)

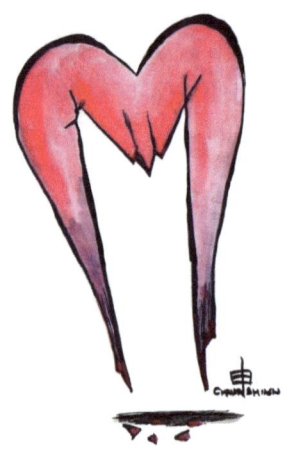

WWW.HORATORASTUDIOS.COM